CATS AROUND THE WORLD
a coloring book

ILLUSTRATED BY EVA CARRIERE

"A cat's eyes are
windows enabling us to
see into another world."

–Irish Legend

QUIXOTE PRESS

Copyright © 2018 by Eva Carriere

ISBN 978-0692188675

For more information, please contact Quixote Press at
quixotepresspublishing@gmail.com

quixotepress.com

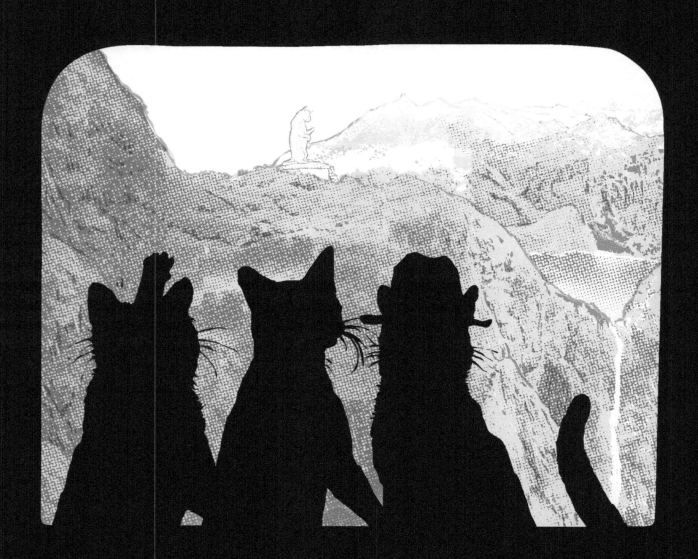

ILLUSTRATED BY
EVA CARRIERE

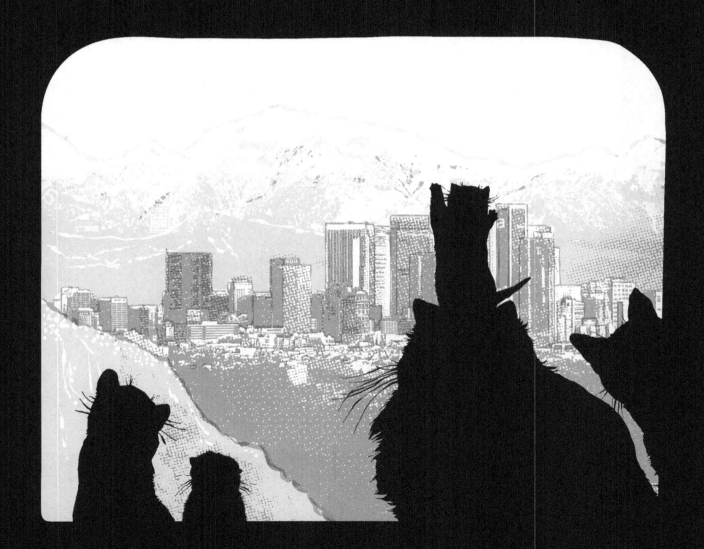

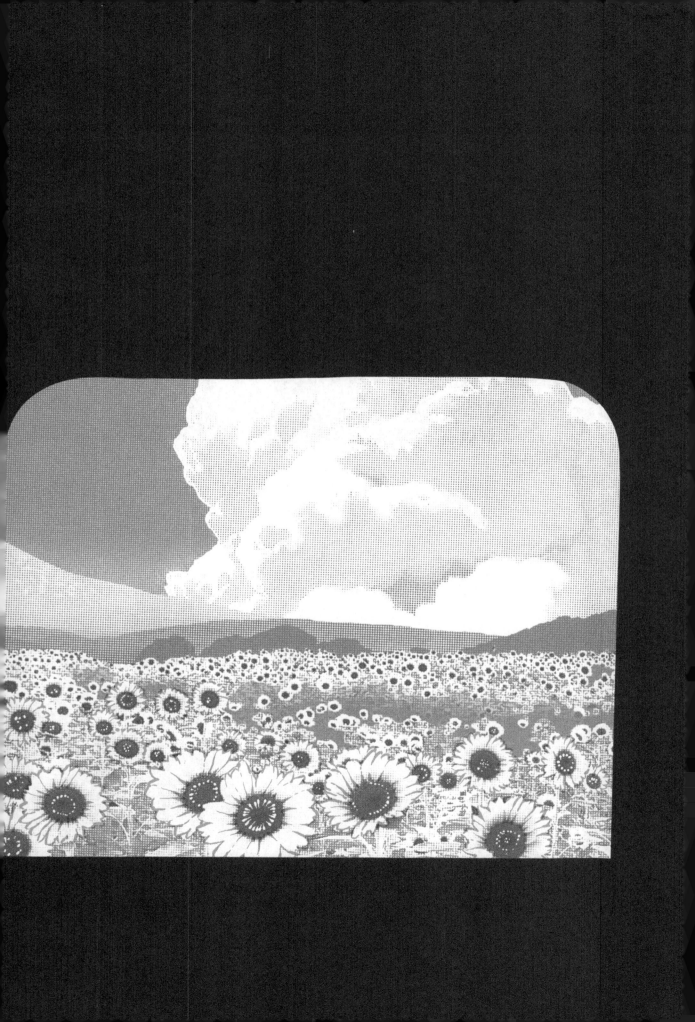

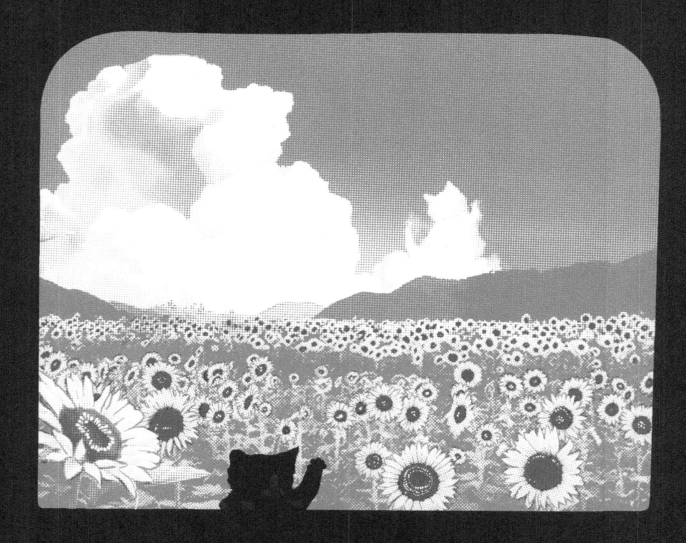

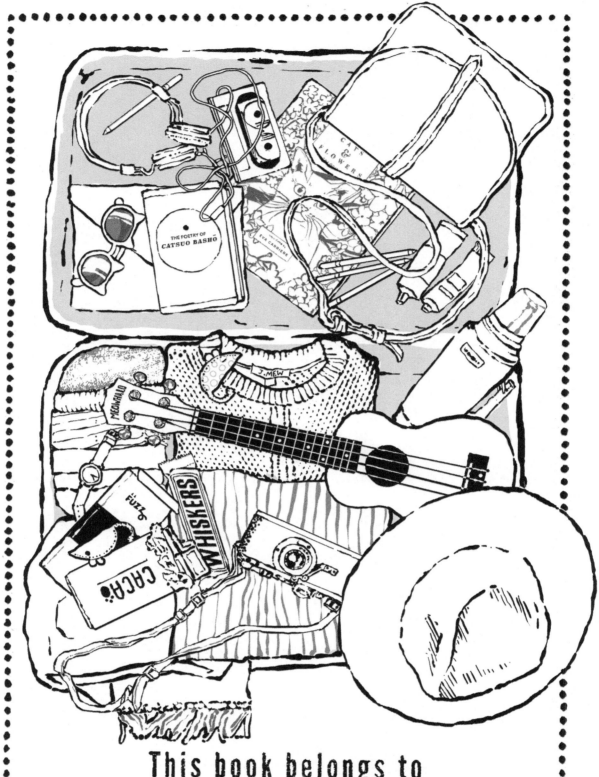

This book belongs to

Test your colors here!

Coloring tip: to prevent ink bleed-through when using markers, be sure to have a sheet of scrap paper stuck behind the page you're coloring.

The bustling streets of
Trastevere, Rome

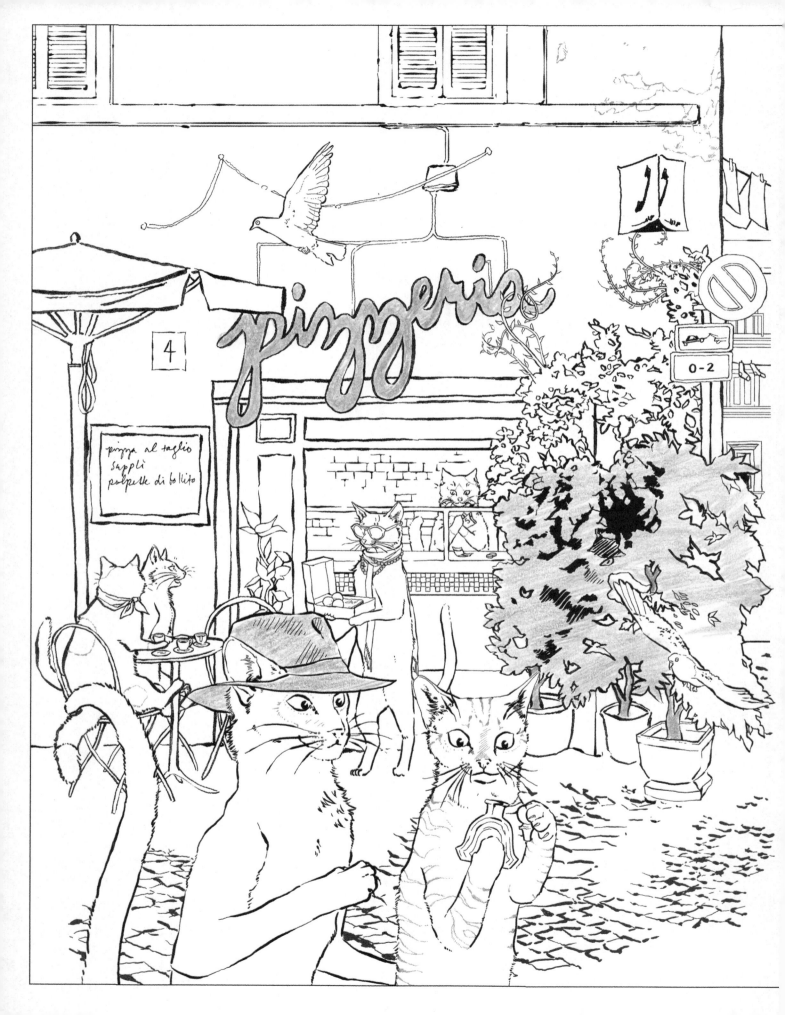

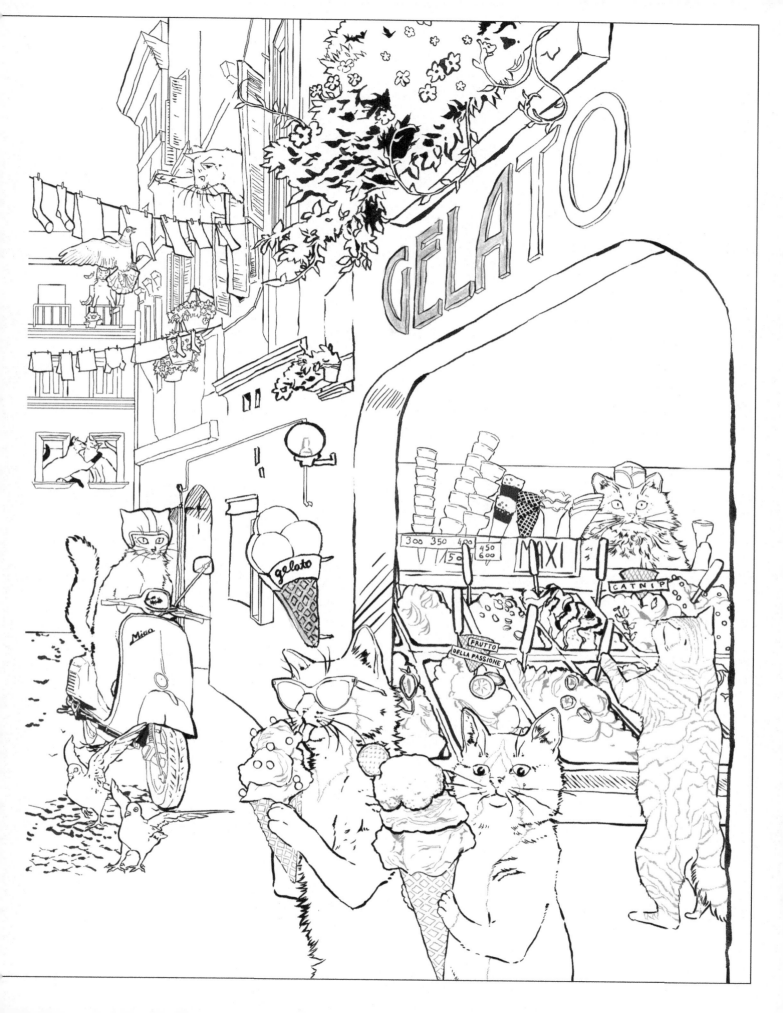

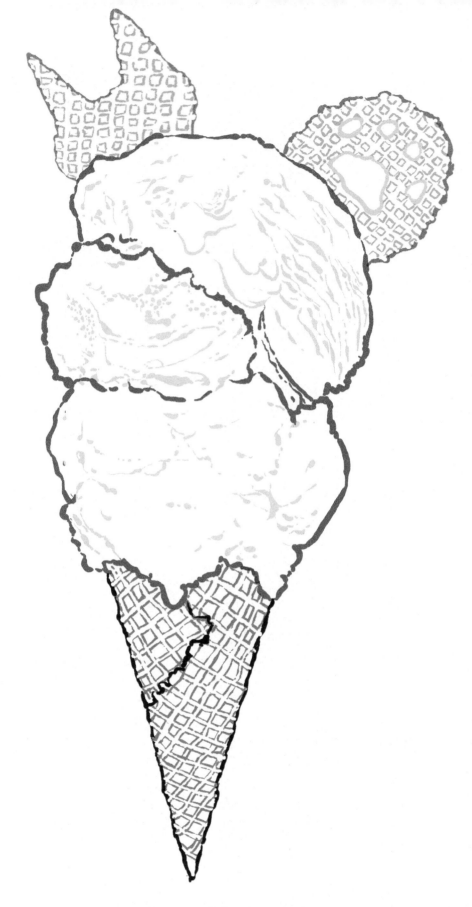

Draw in your gelato toppings!

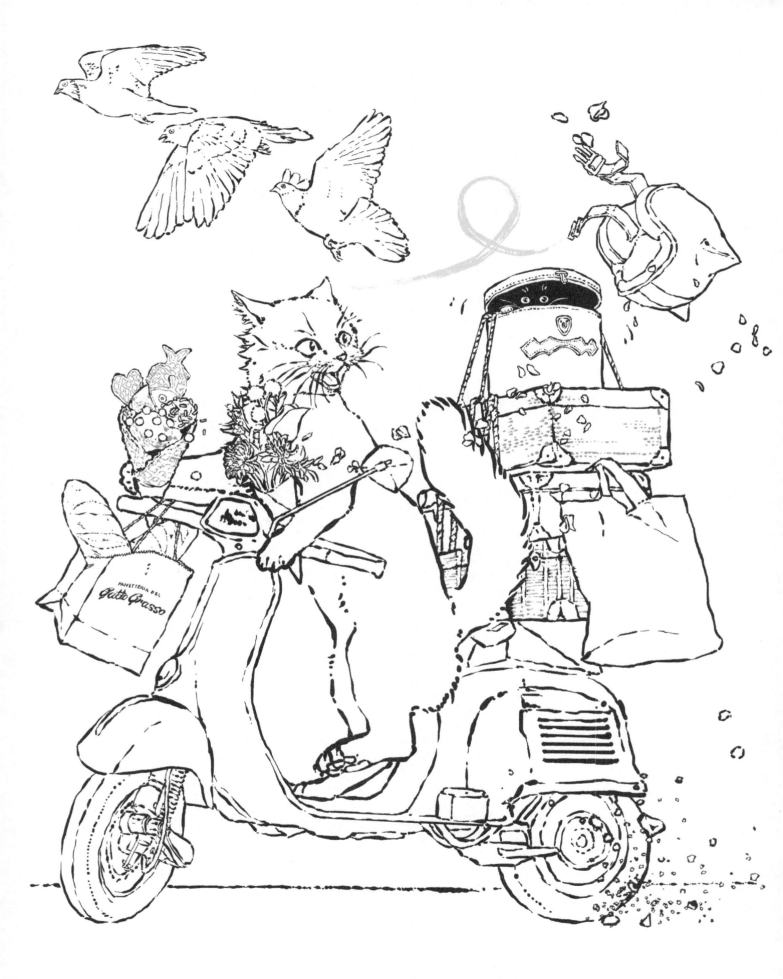

A textile shop in

Marrakesh, Morocco

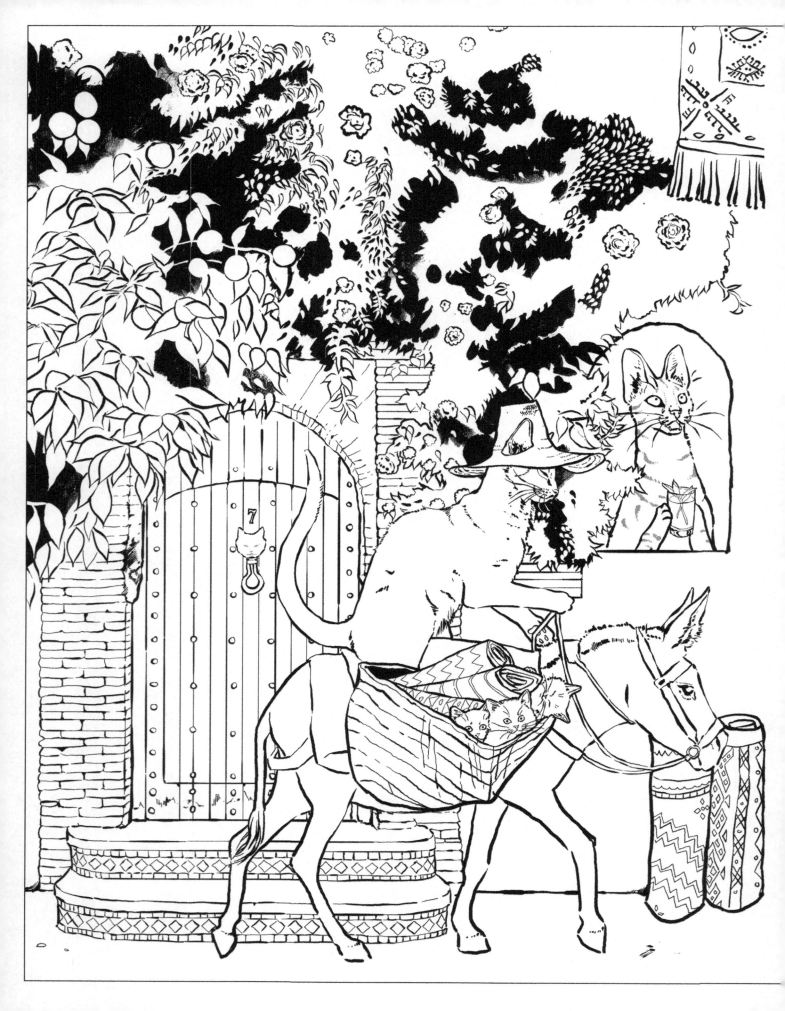

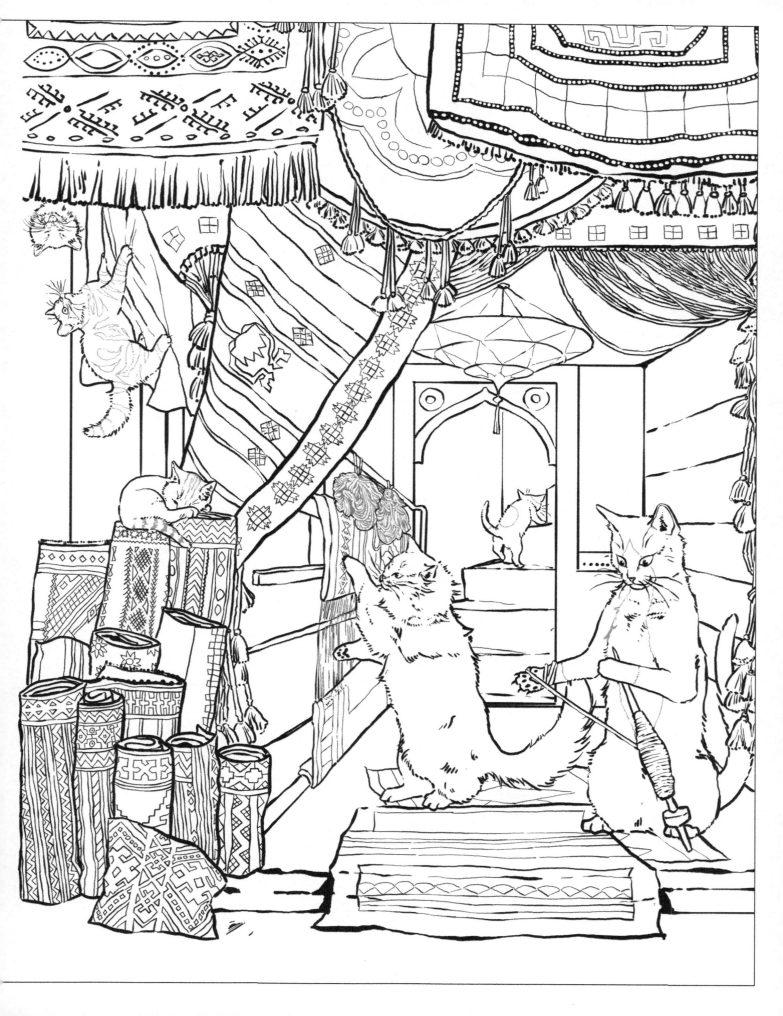

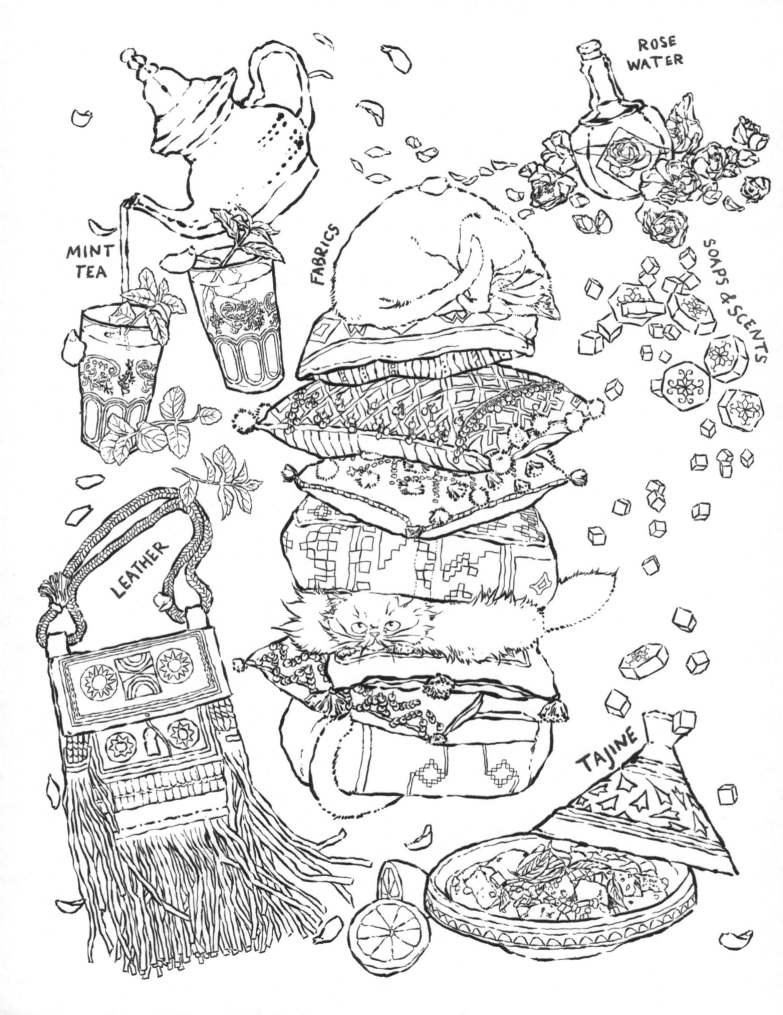

Swimming with the sea turtles in

the Yucatán Peninsula in Mexico

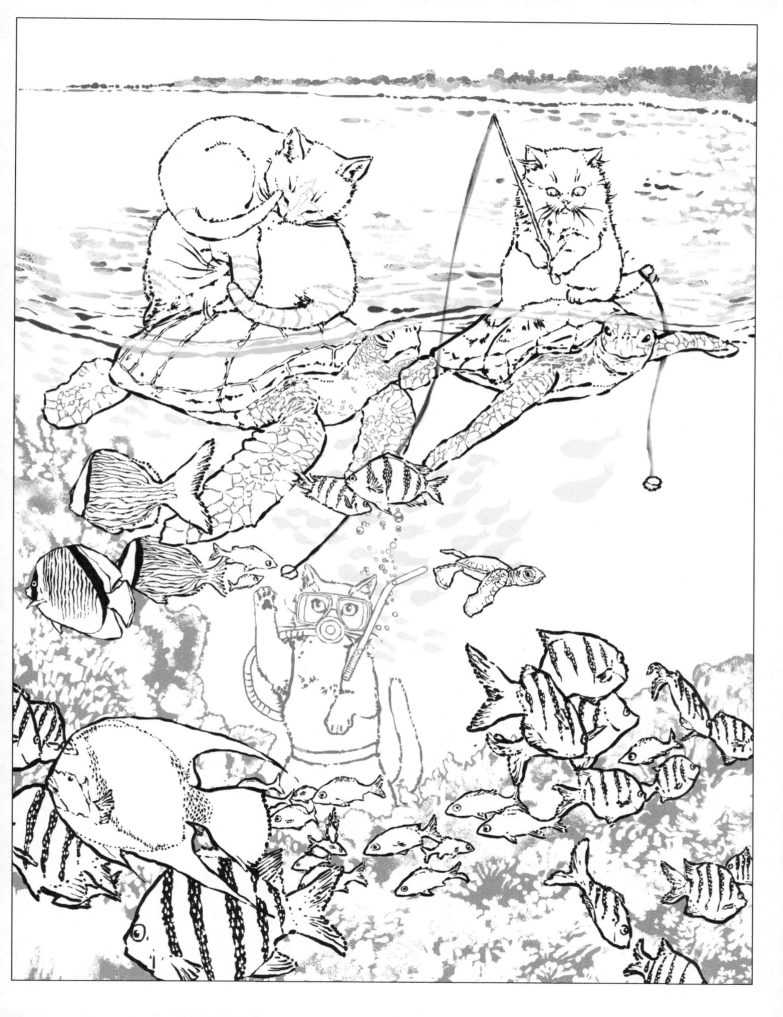

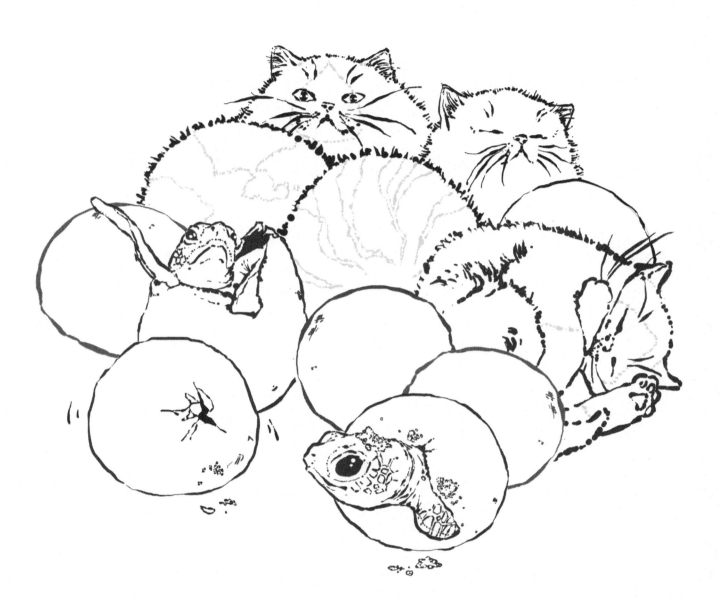

An old fashioned garden party
on the rural outskirts of

St. Petersburg, Russia

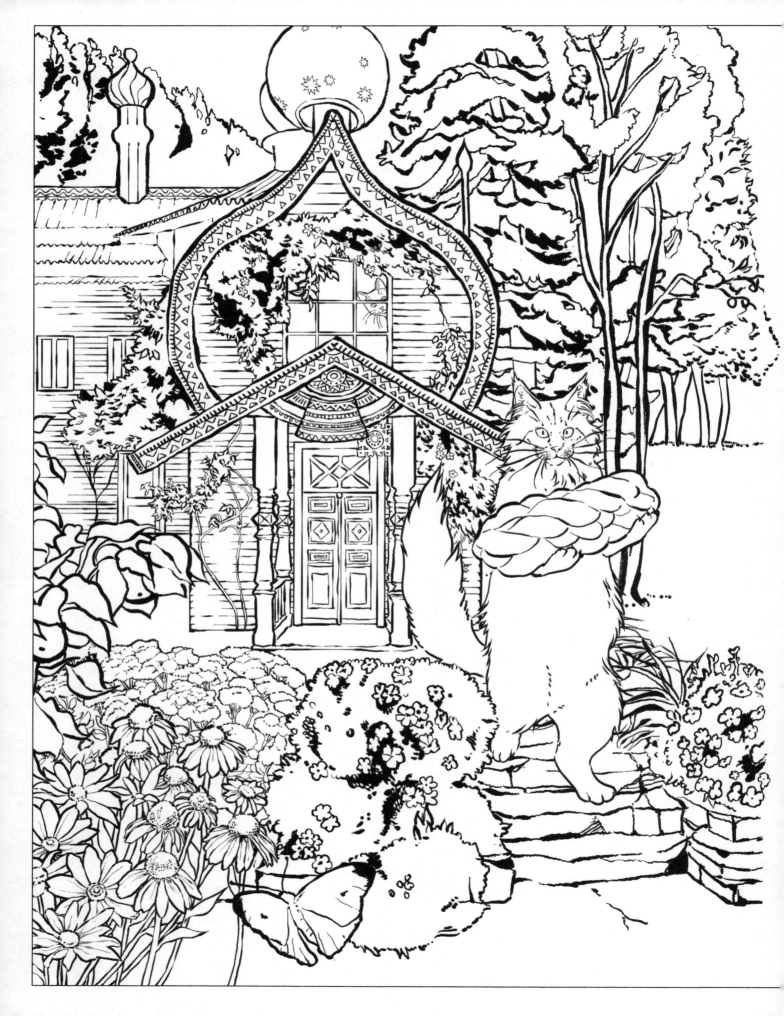

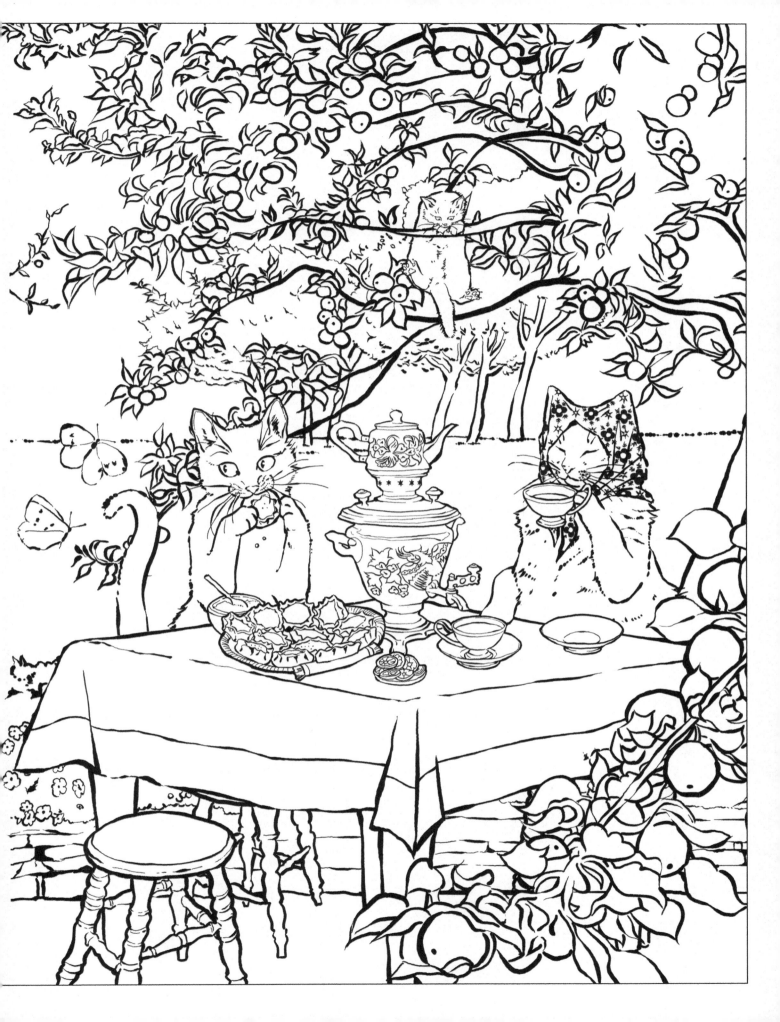

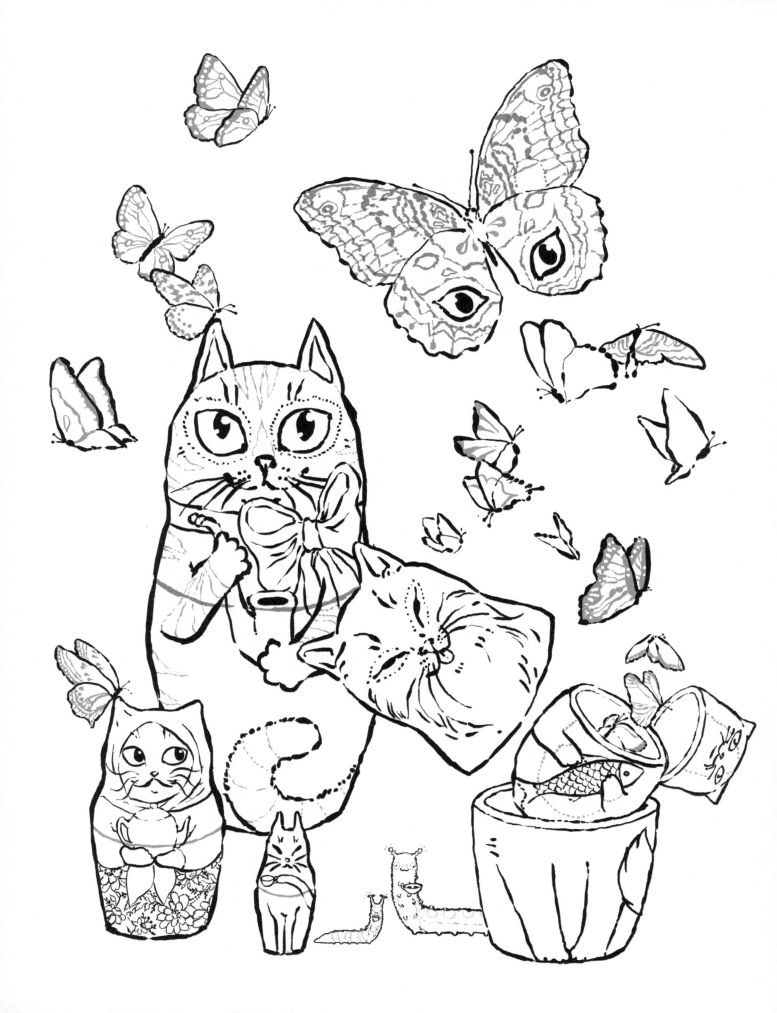

A fishing village of

Hạ Long Bay, Vietnam

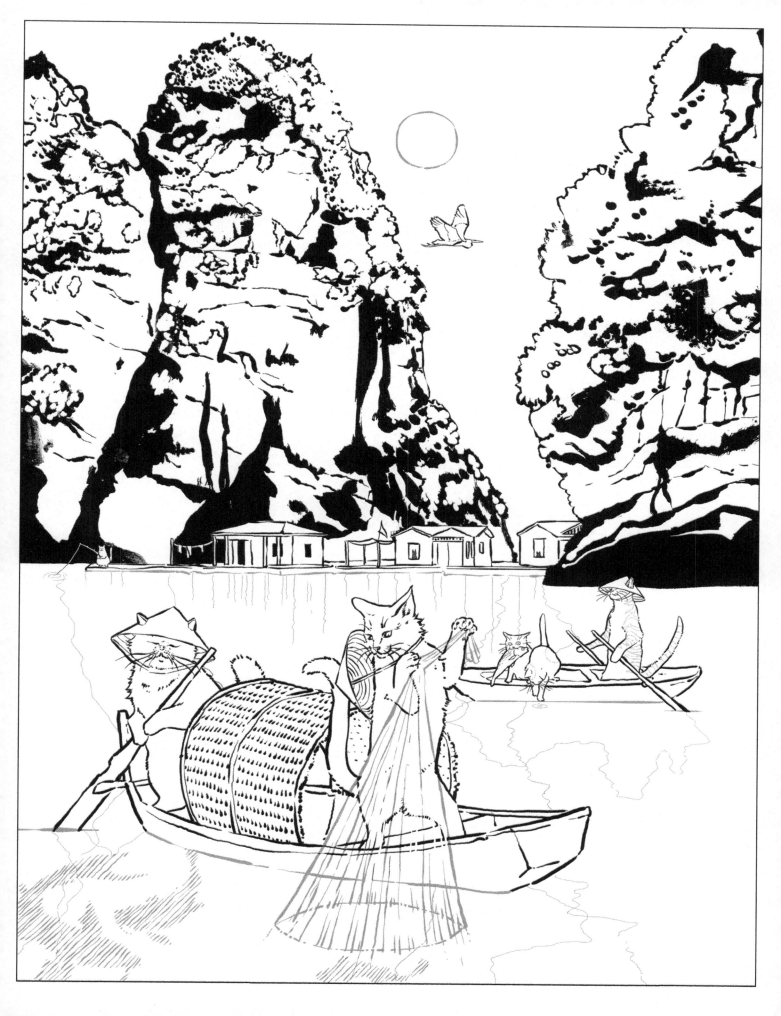

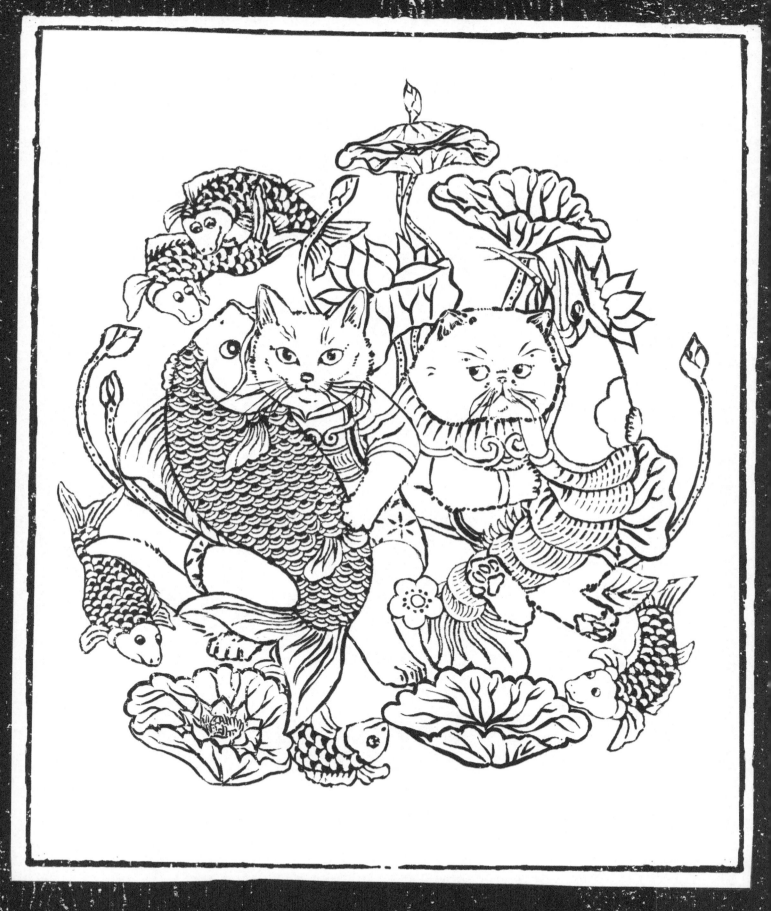

A "traditional" Đông Hồ folk woodcut painting...

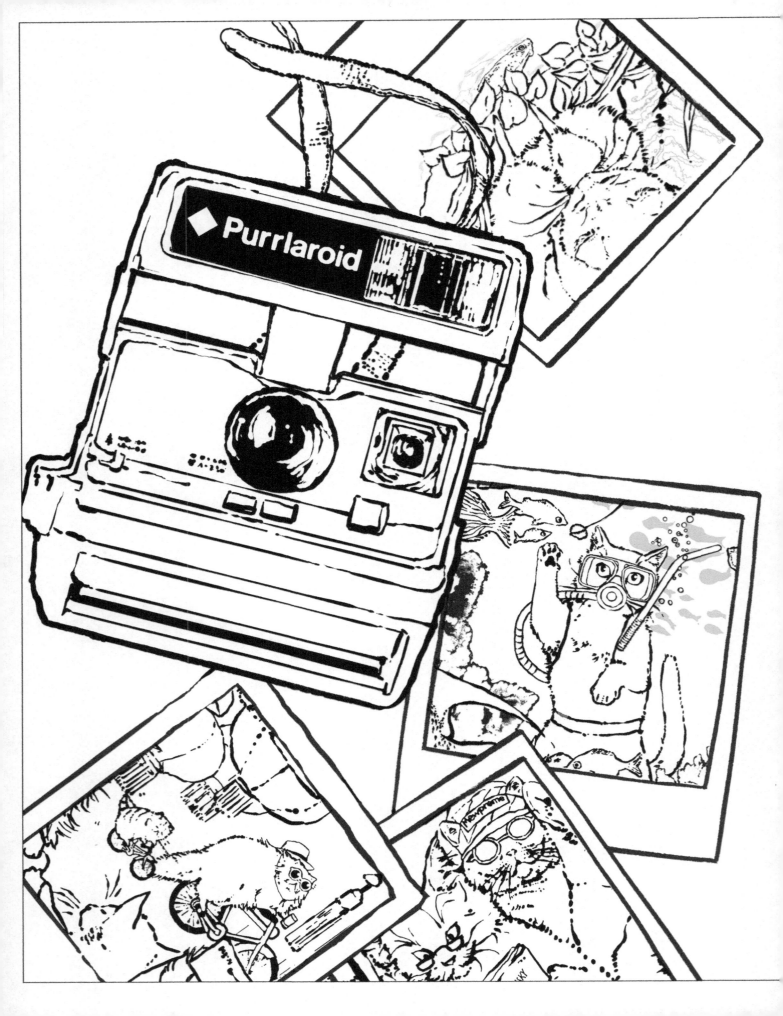

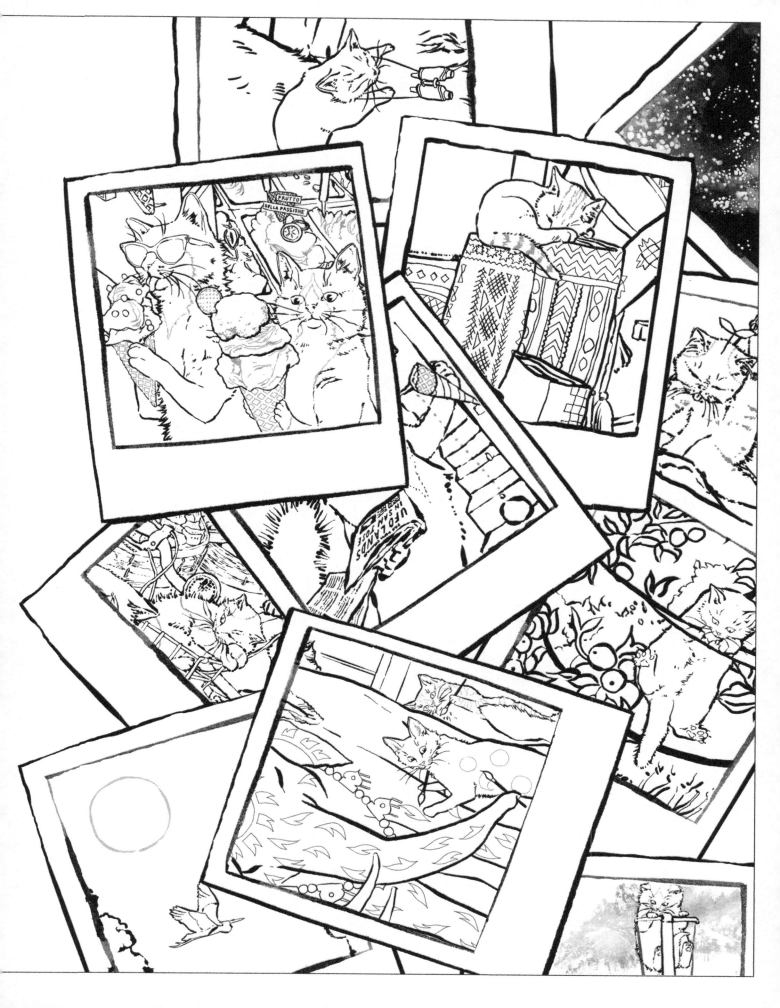

Catching a trolley in

San Francisco, California

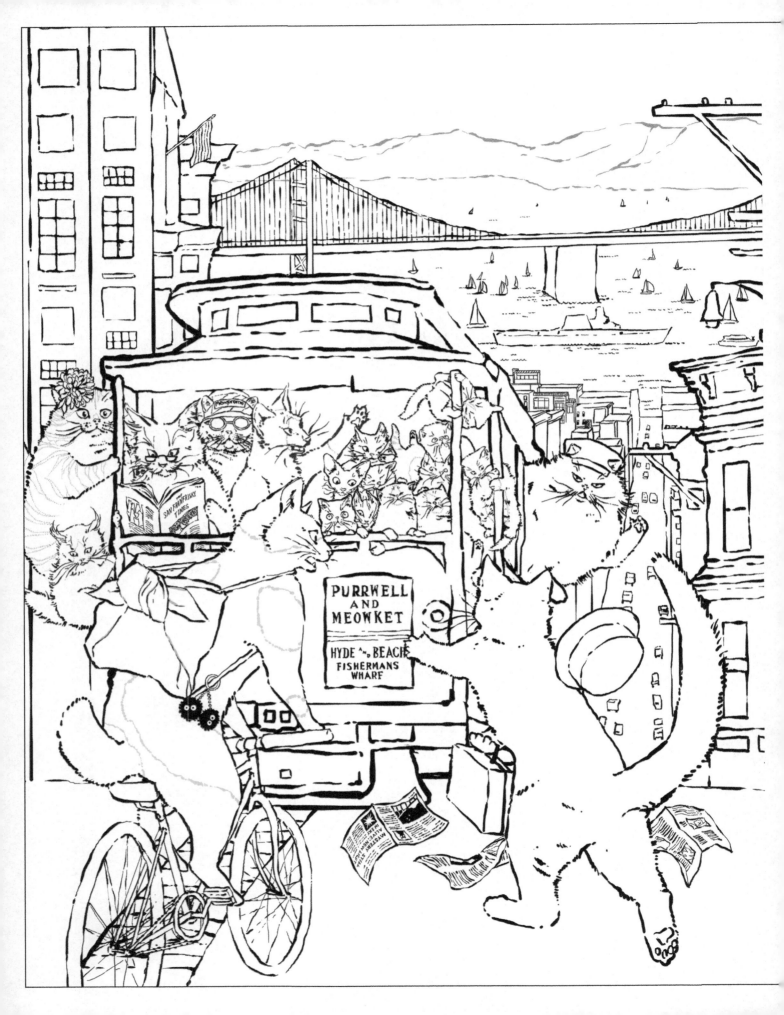

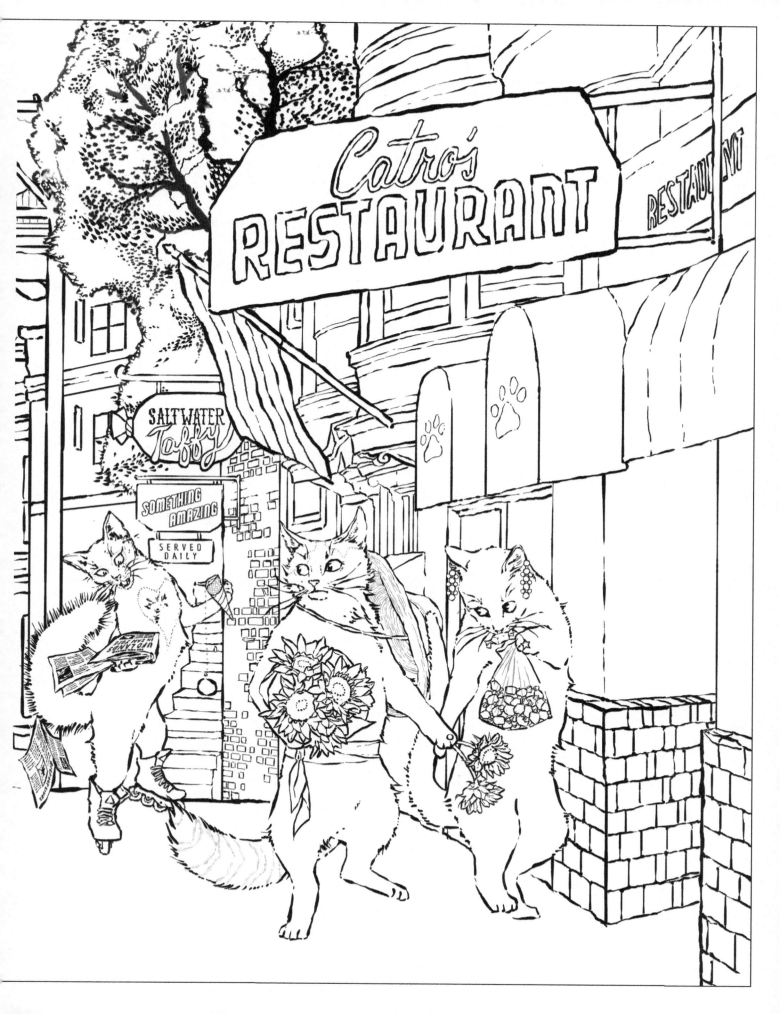

saltwater taffy

Exlporing the glow worm caves of
Waitomo, New Zealand

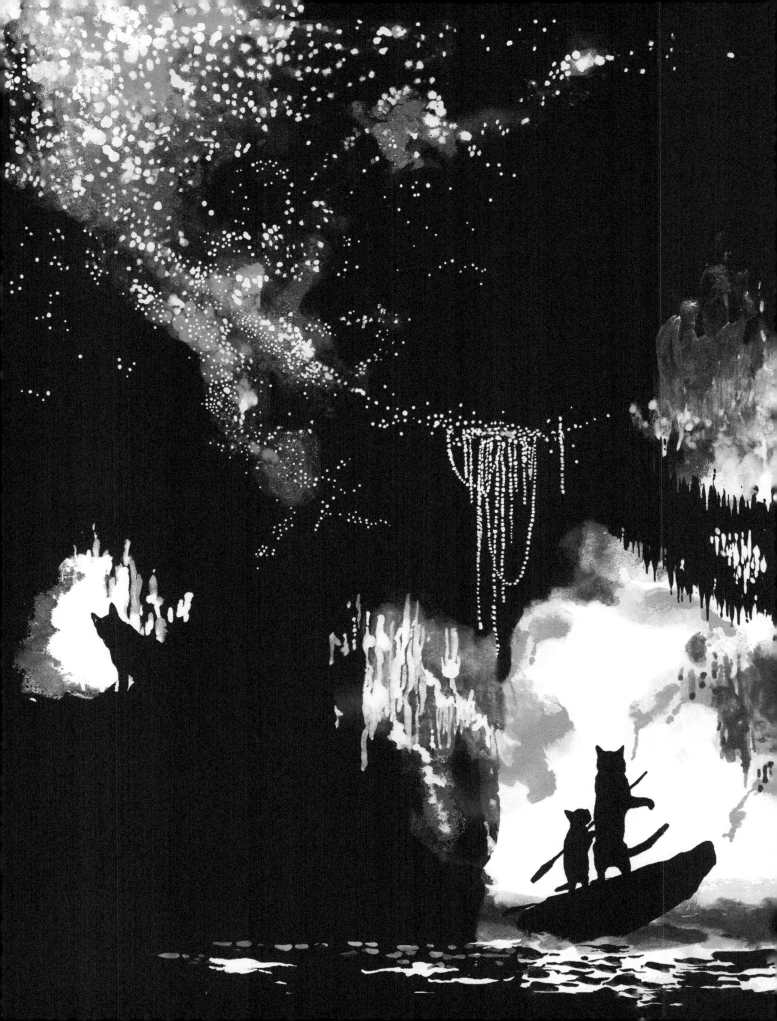

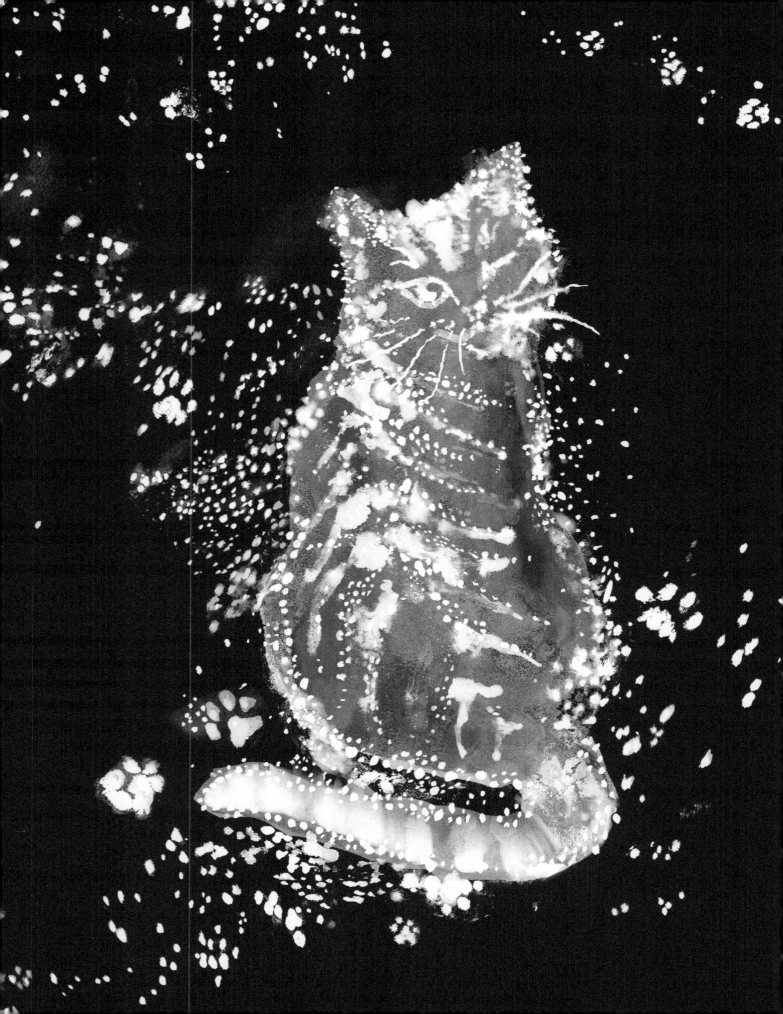

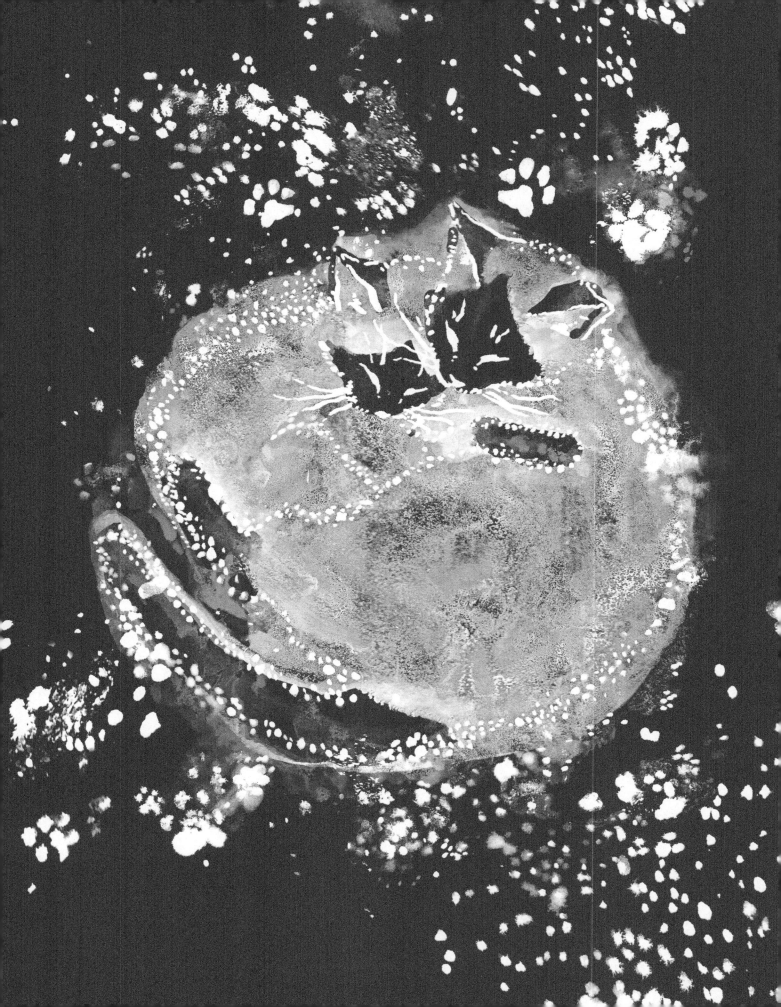

New Zealand's kiwi birds have whiskers, too...

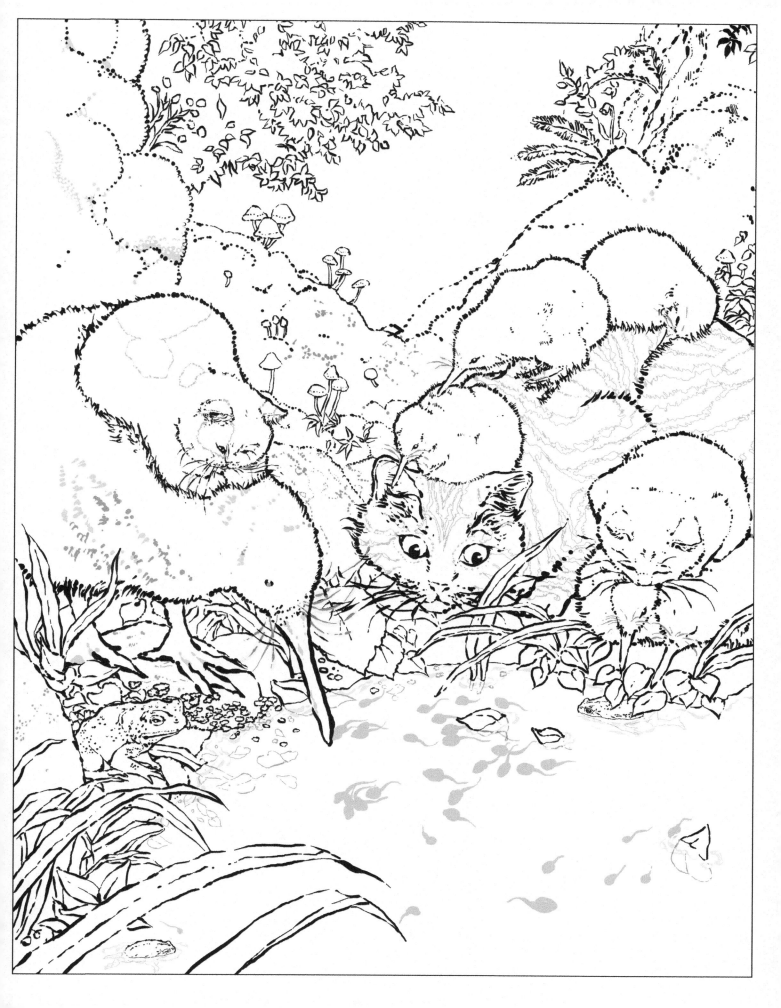

Painting elephants in
Jaipur, Rajasthan

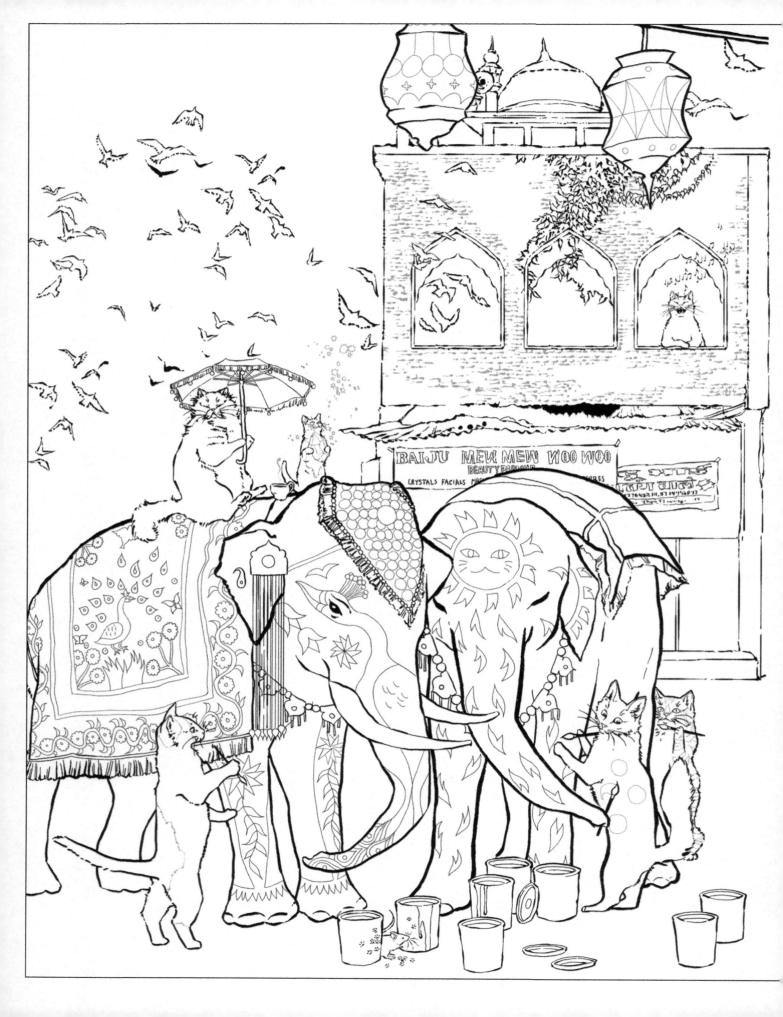

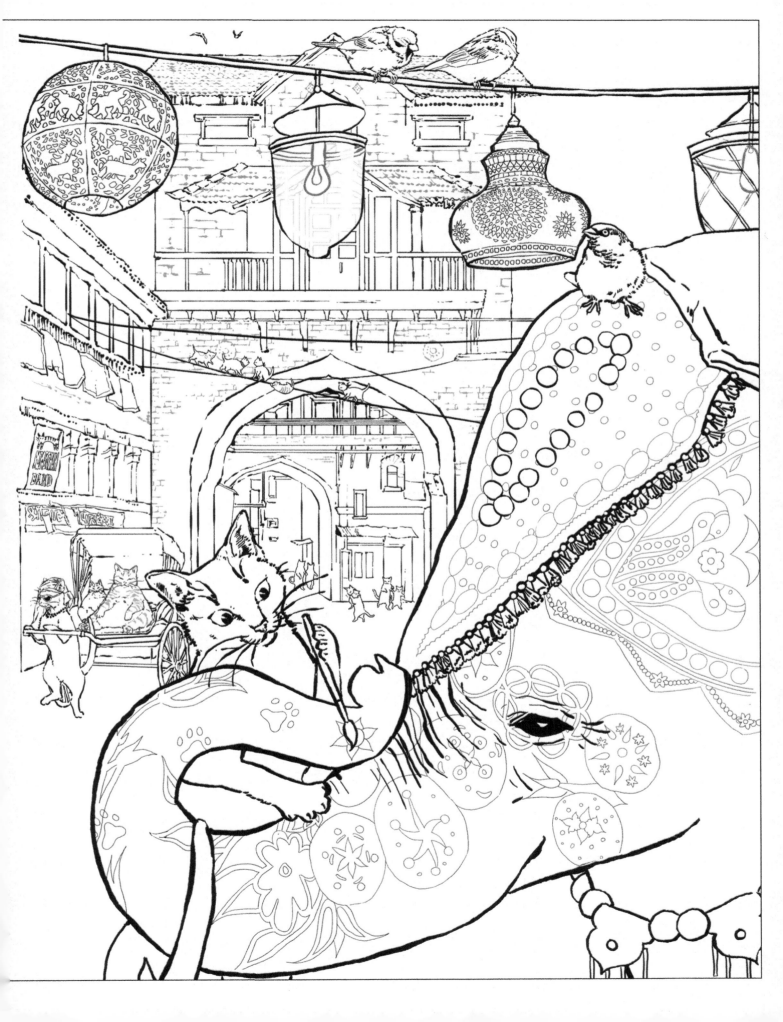

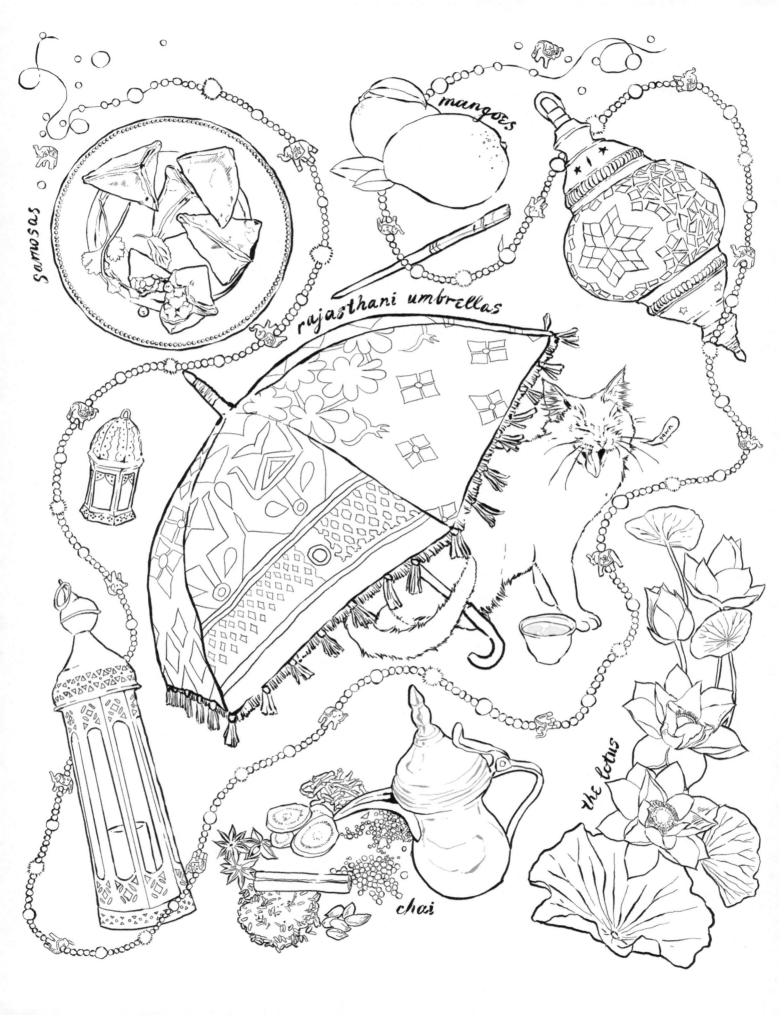

samosas

mangoes

rajasthani umbrellas

chai

the lotus

Bryggen Wharf of
Bergen, Norway

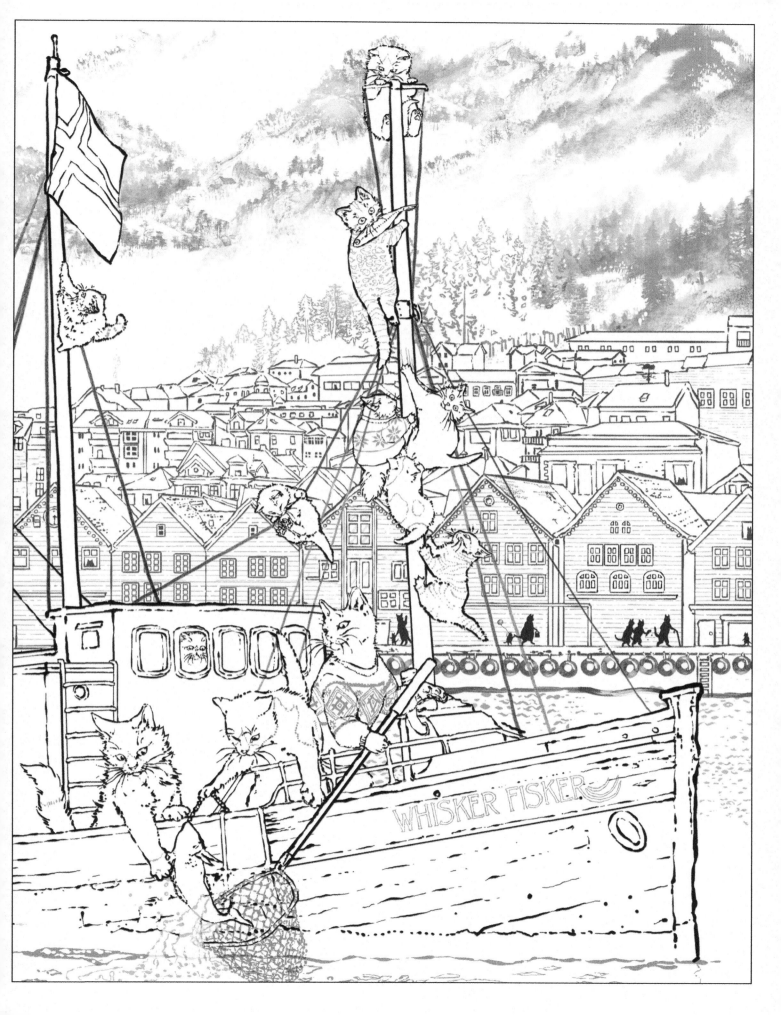

Bergen's bright, beautiful houses

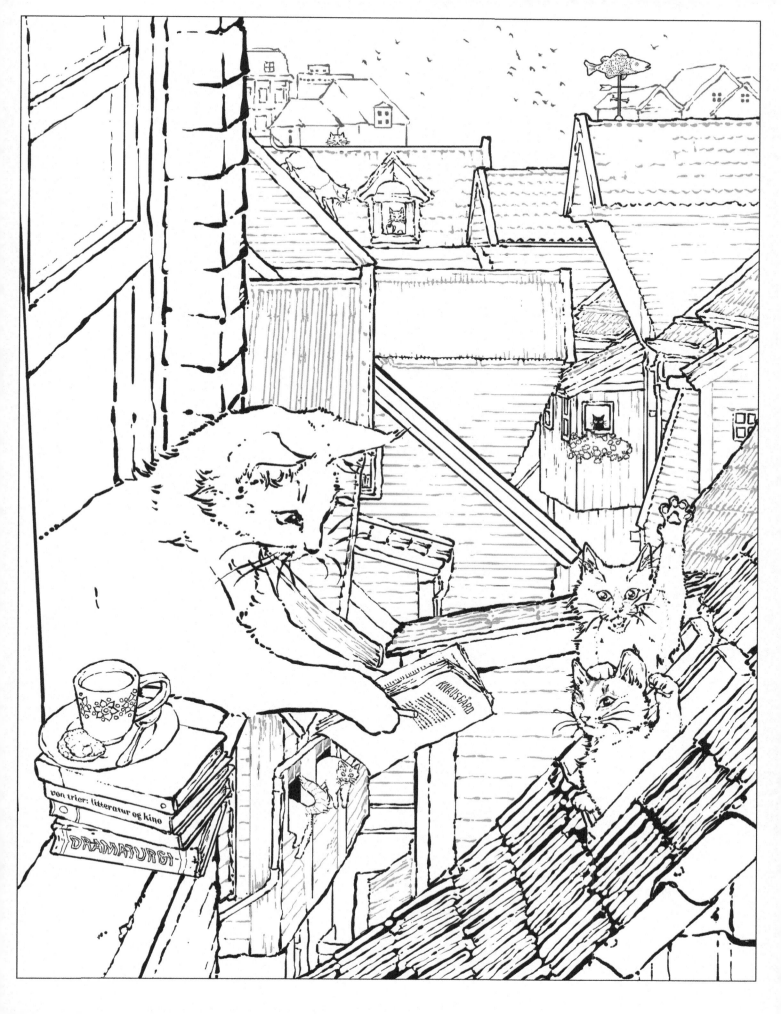

The Machu Picchu ruins in

Cuzco, Peru

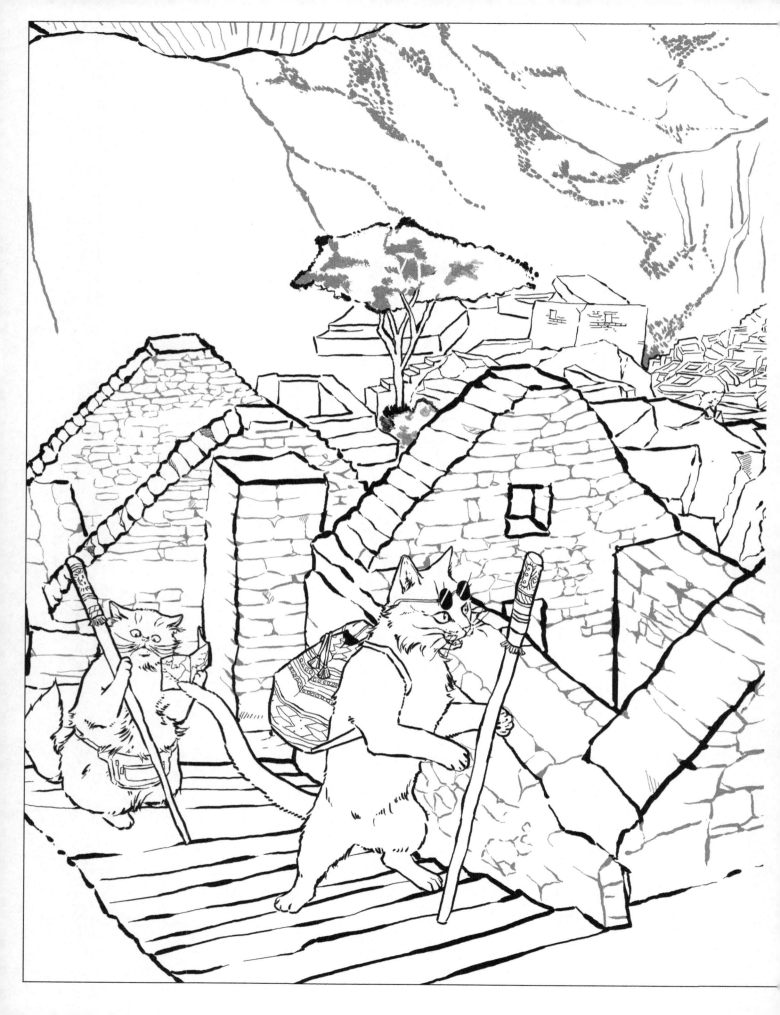

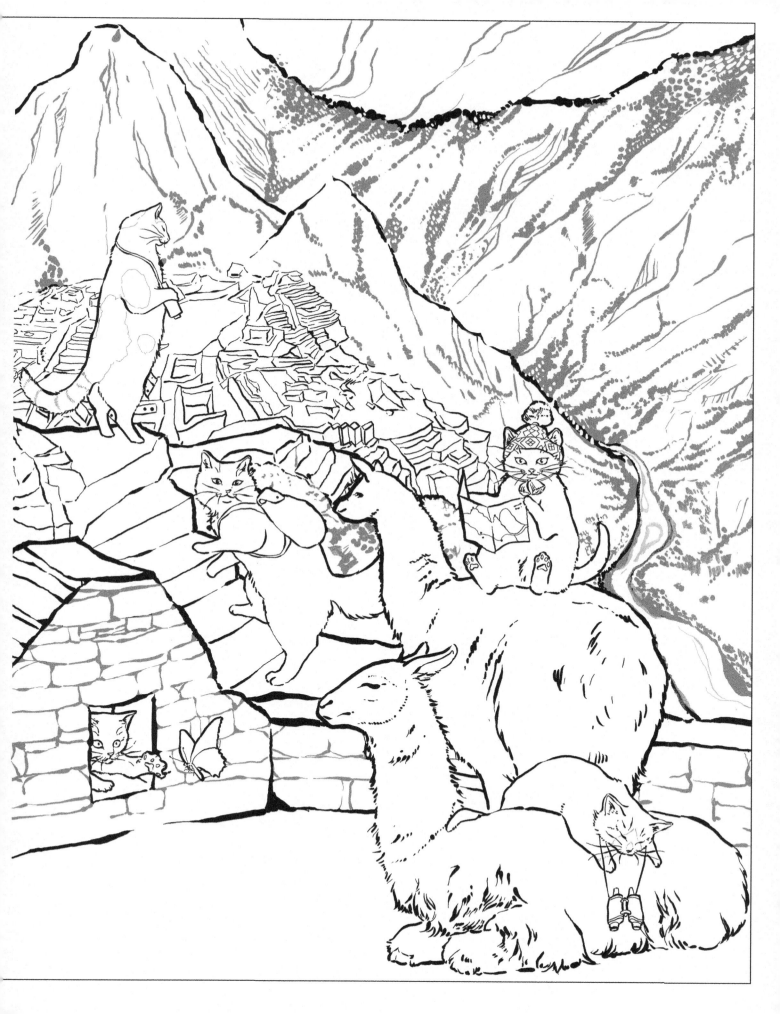

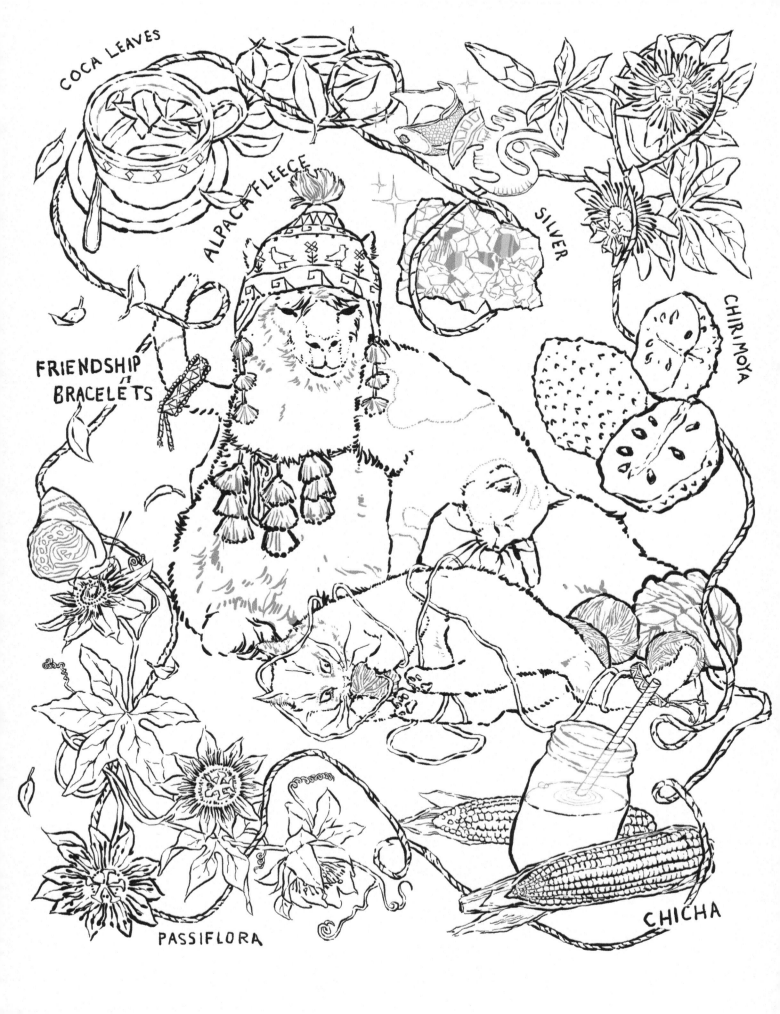

COCA LEAVES

ALPACA FLEECE

SILVER

CHIRIMOYA

FRIENDSHIP
BRACELETS

PASSIFLORA

CHICHA

A street market in

Mong Kok, Hong Kong

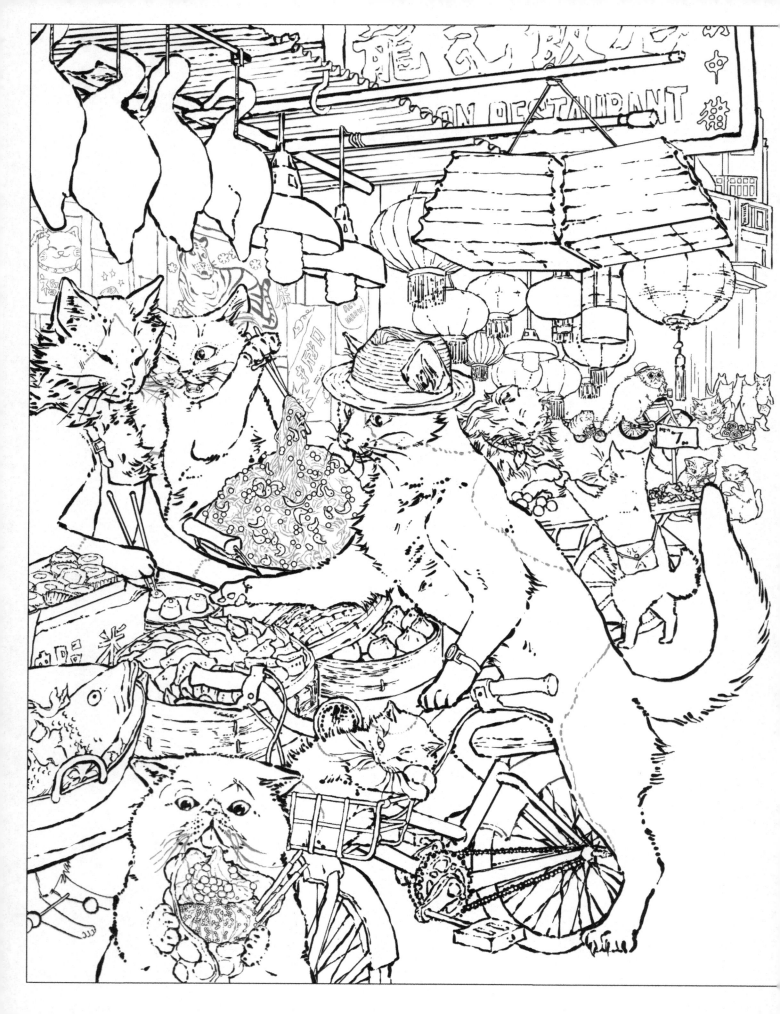

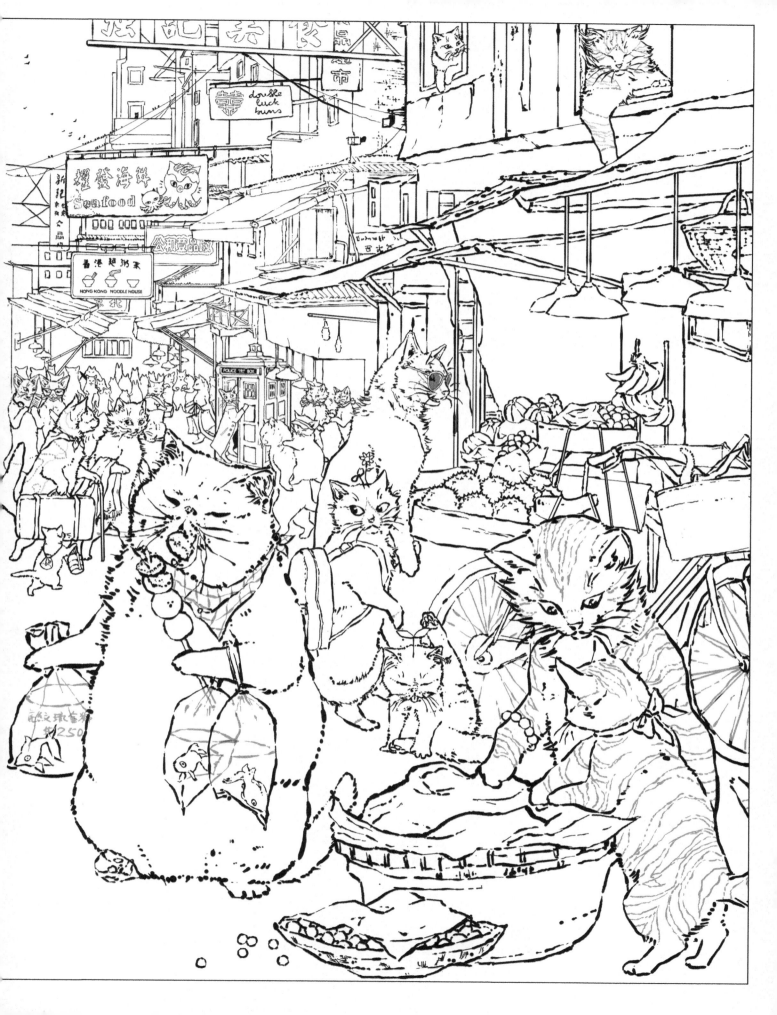

Mong Kok's famous goldfish market

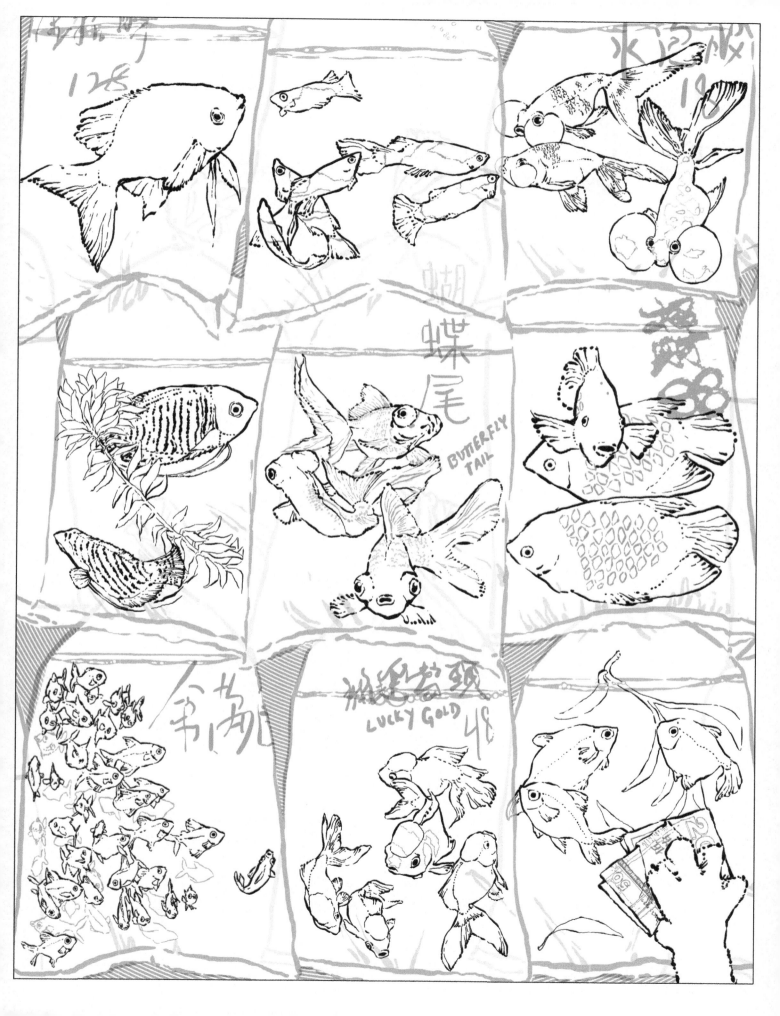

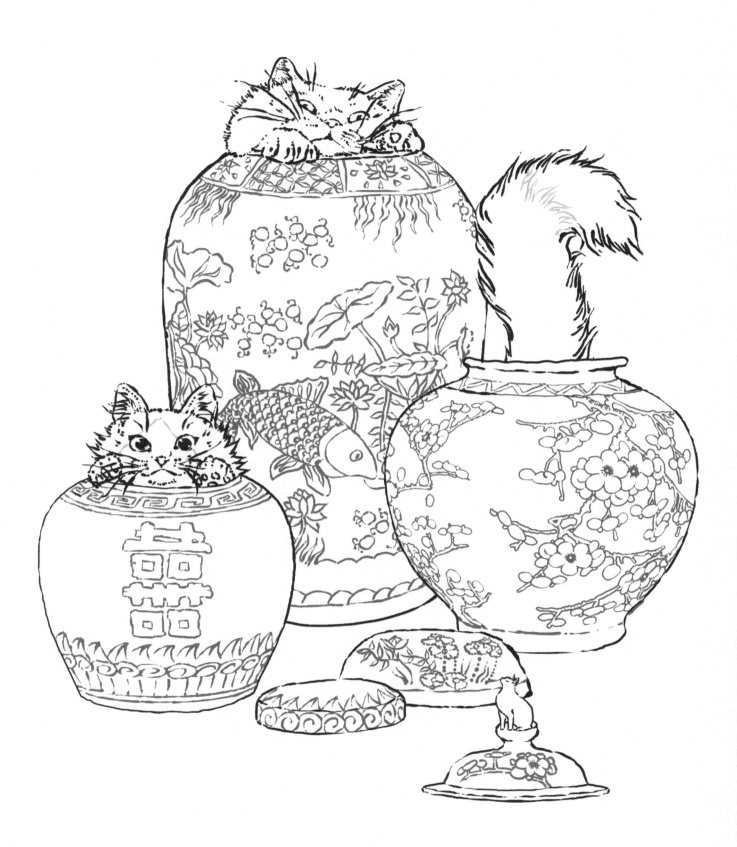

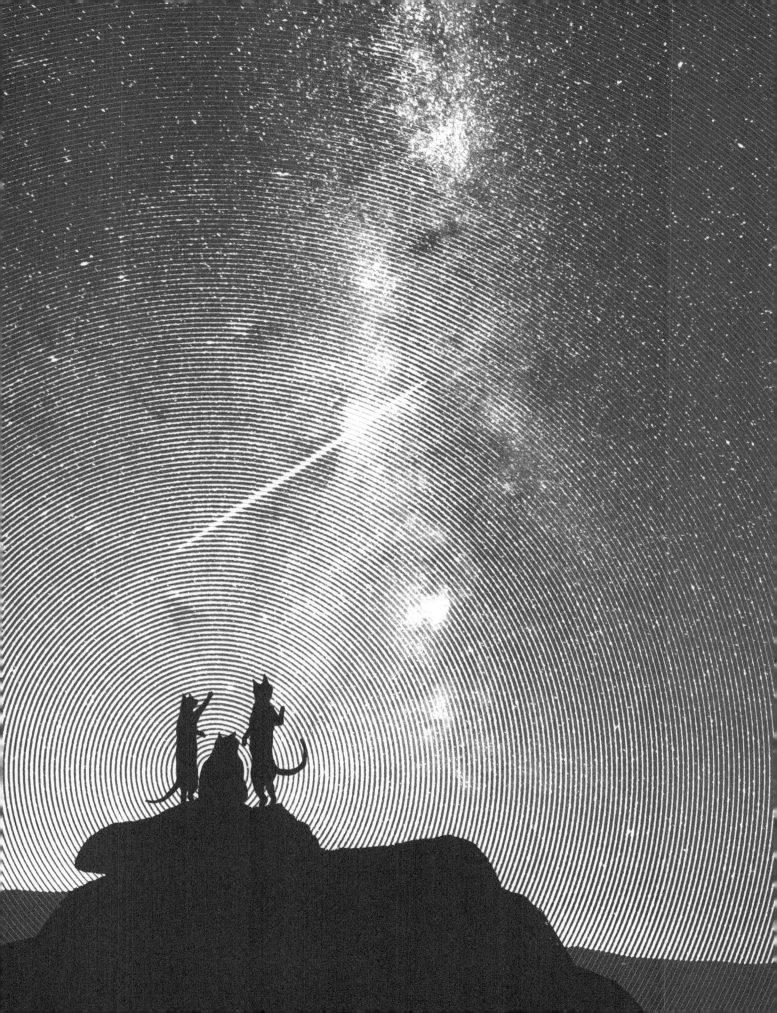

Contact the publisher and see other

publications at

QUIXOTEPRESS.COM

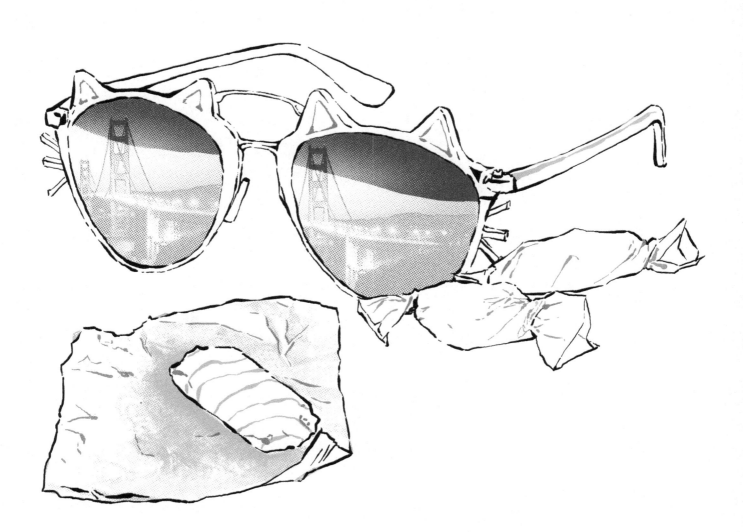

Made in the USA
Middletown, DE
05 July 2022